"Razors pain you, rivers are damp,

Acids stain you, and drugs cause cramp.

Guns aren't lawful, nooses give,

Gas smells aweful.

You might as well live".

-Dorothy Parker "Enough Rope"-

"Death is imminent". Now there is a cliche, an absolute truth. How each of us respond to it or handle the thought of it, however, greatly varies. Many of us fear it, some of us welcome it, some choose to help it along and others explore it, maybe even mock it. After all, the dirty deed will be done, so while I personally do not tempt Death to take me earlier than necessary, I can certainly decide to poke fun at my own demise. It is my only recourse in battling any anxious feelings I might have about "my time".

 While some might find this disturbing (and some of the images are), I try to imagine that Death might find it amusing, as if we might sit in a room side by side on a plush, velvet sofa, pouring over the images while sipping on Manhattans. Occasionally we stop on one, study it for a moment, then simultaneously burst out with laughter at the humor in it all. Death smirking, "Oh that's a good one"! Me responding with pride, "Right? I love the title. I think I even tried that once"! Then more laughter ensues.

 I have had friends suffer tragic losses, mothers I know that have lost children, and friends saying good-bye to young friends. I have witnessed countless individuals young and old dying in the hospice I volunteered for. I have had my own losses. I watched the color fade from my grandmother's lips as her heart failed from age and death slowly fell over her countenance. I felt a young child's heart stop beating within me, and as I grow older I seem to witness more and more deaths as if the passing of time increases the momentum of death around me. So, some might ask, "Why make fun? Death is not a joke".

 My short answer is, this is not about others tragedy but my own photographic study of my physical death. These are not images depicting the demise of friends, relatives, or of the losses they have collected, but are in essence, self-portraits of my expected passing and an exploration of the question, "How will I go"? I have chosen to face the sadness and the horror, and the humor in it all, simply because I have no other choice.

 I chose to have the photos taken with a hand held phone by friends or family, not to give too much seriousness to the process. Often in these modern times this is how the image of death is captured, voyeuristic intentions quickly plastered on the walls of social media. In death, there no longer seems to be any privacy, the small camera phone ever ready to snap a shot of another's ill fortune or the face in the coffin.

 As the ideas of this project were conjured and the images created, I often wondered, "Have I already photographed my own death"?

<div style="text-align: right;">Shelley S. Smith</div>

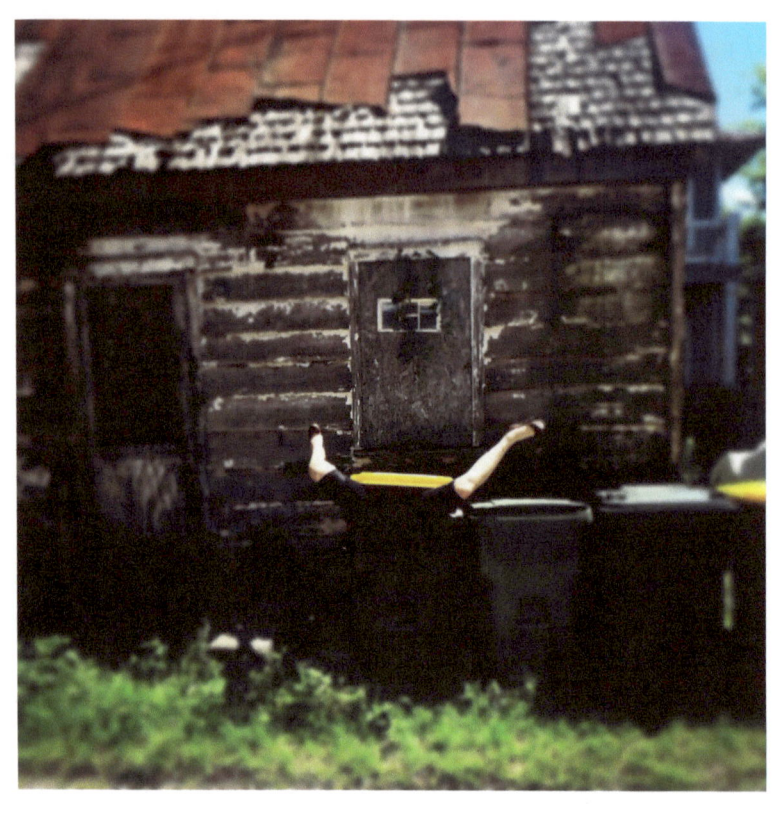

"We're Going to Clean This City Up"

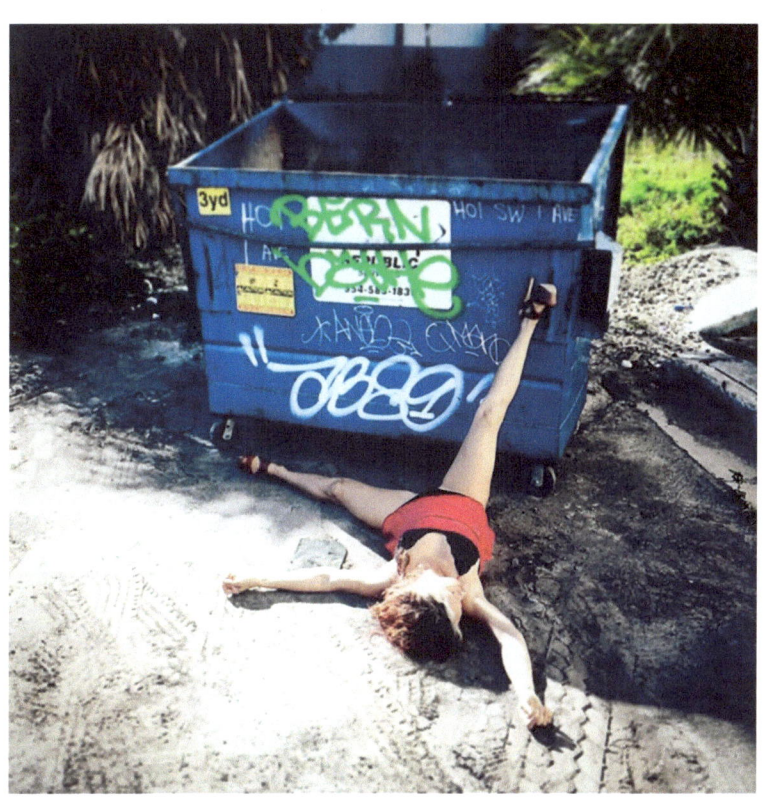

"Taking the Trash Out"

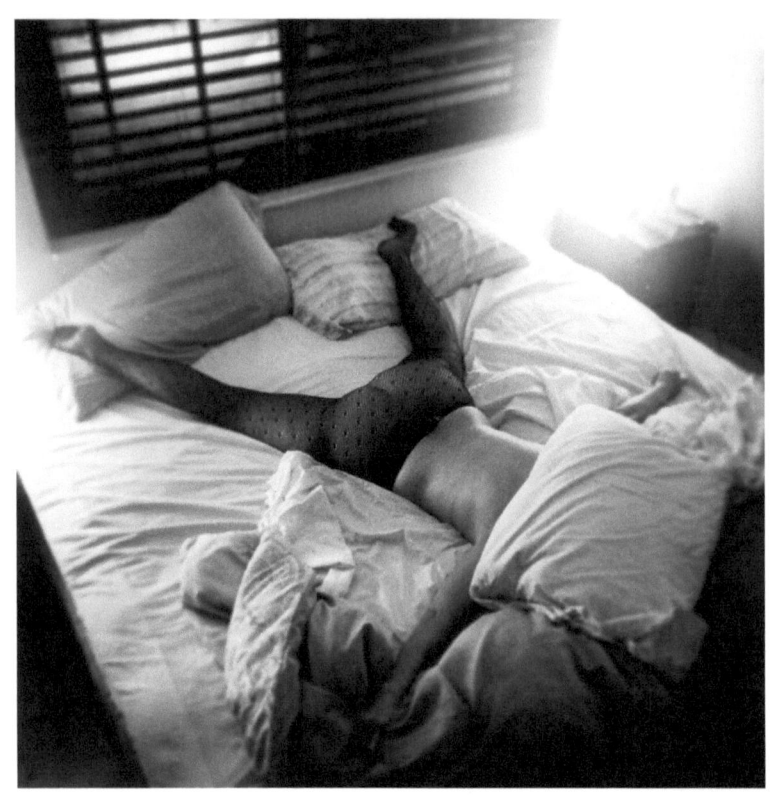

"Time for Bed, Honey. Lights Out"

Cinderella

Did you search through magazines,
aging white pages,
or yellow pages,
under "in betweens" or "casual aquaintances"?
Did you find him in
the spaces between the texts,
and the lines,
and the sex,
and the lies,
betwixt the silky,
and the sumptuous
emails...(oh sigh).
and the "big sad man" cries?

Was he there for you?
or the dot coms?
Did you order him from apps
and was he young or cd.rom?

Even if you touched him,
kissed him, fucked him,
wrestled him, left him
(oh God the fight).
The flesh, it becomes intangible,
and the bullshit of you and me
"unhandable".
It sickens and is laughable,
this lust is bloated,
but the love is fallible.

This story is a fairytale
made real and so fucking stale,
grasping for these moments...a Cinderella moment.
(drop that shoe)
run home, he's not for you,
he was just a screw,
a feeling, a sensation,
an orgasm, an elation.

Think nothing more.
There's no love here.
No, "I do".
These things Dear Cindy,
are not for you.

1/11/2015

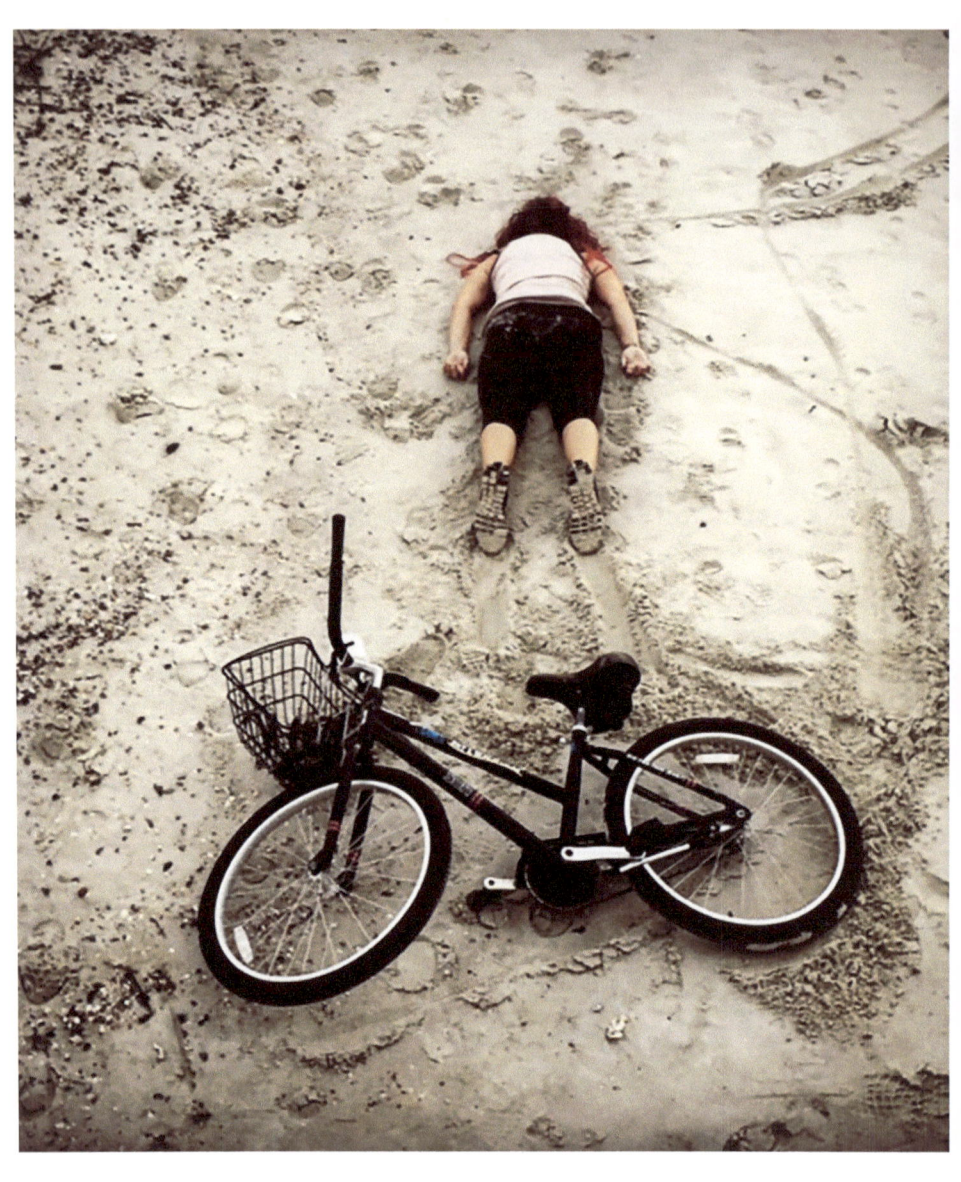

"It's a Great Day for Biking"

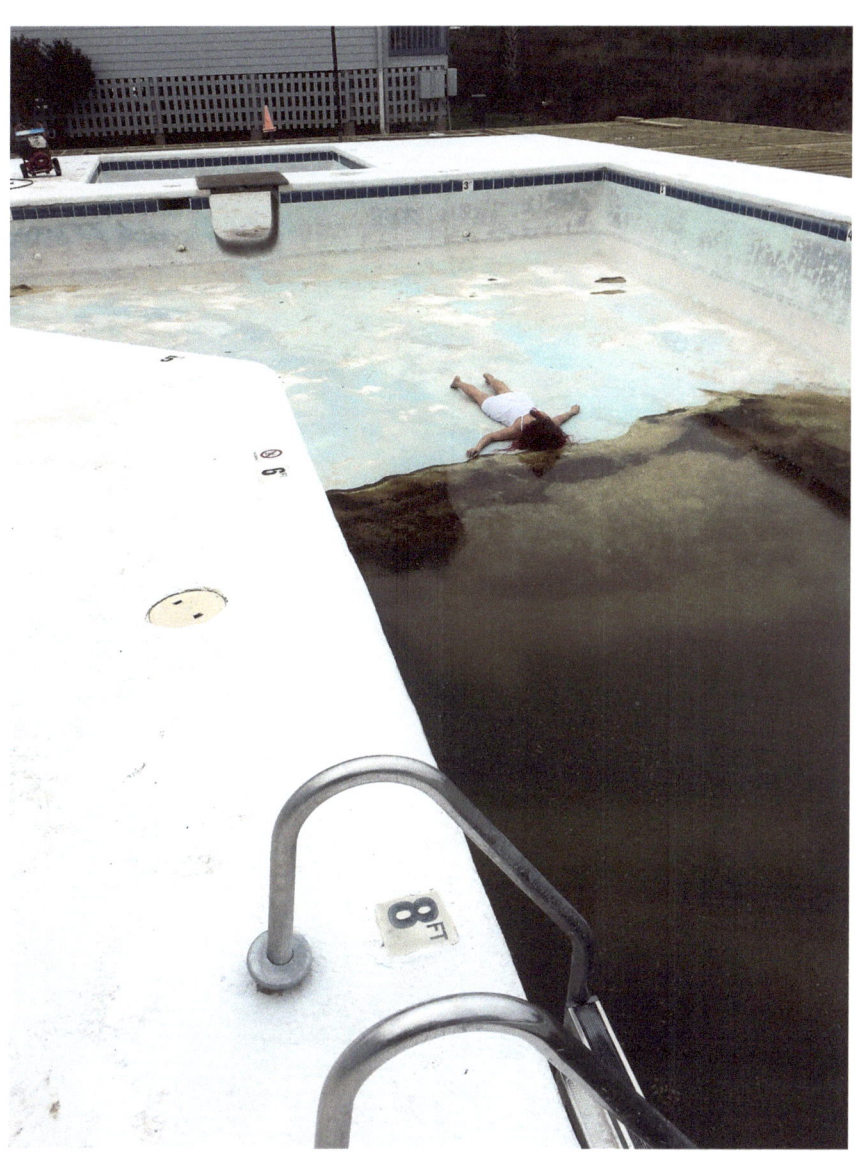

"No Swimming"

Six Minutes

My fortune...
the six minutes have begun.
i do not know when they started,
the catastrophe that won
and brought me
to this wicked stopwatch,
this mortal countdown,
this final notch
to the infinite zero.

and so it begins,
six minutes to recall
the dream,
my life,
all...
and none.

if it were a bullet,
a crushing car,
a hammer divine
these seconds might not be mine.

My fortune...
to grow cold with my six minutes...
to witness my lifetime,
judge it's journey
a good life or a bad one?
missed moments, regretful ones,
golden nothingness,
fleeting bliss turned to sour hours.

no matter.

60 seconds left on the clock
and all i see now are the faces i loved,
a perfect kiss,
a hand held,
my mother's face,
looking down at me in my crib.

2015

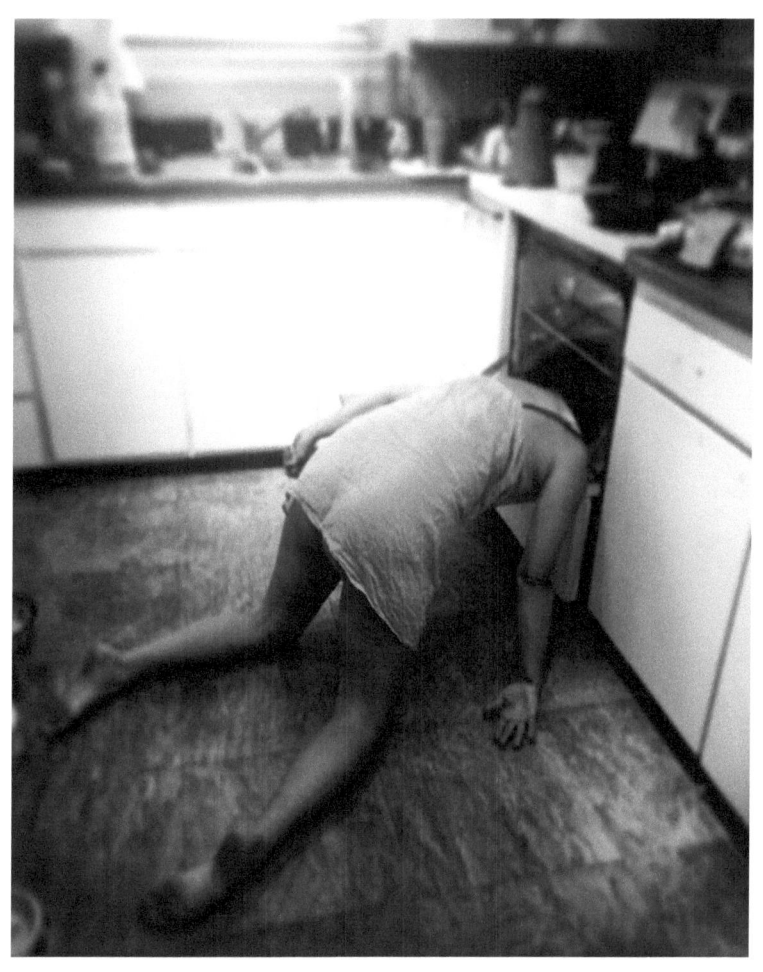

"Hey, Good Lookin. What's Cookin?"

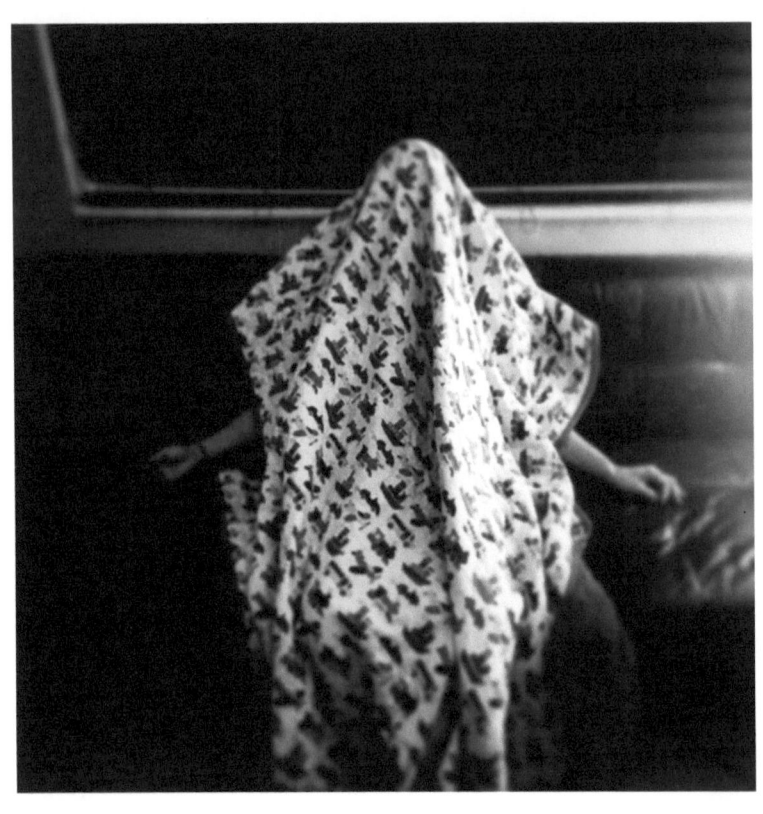

"I Seemed to Have Caught a Chill"

44 Years

44 years, 4 days and 4 hours
I've cuddled with thorns,
and I've crushed fledgling flowers.
Some said I was strong,
others said I was clever,
but what I was good at,
was not good enough ever.

44 years, 4 days and 4 hours,
I gave birth to ideas, but babies, no never.
I gave birth to business, but success was illusive,
and I mingled with many, but it was never inclusive.

So, 44 years, 4 days and 4 hours,
I sit on this dock on this creek and I ponder,
and like that distant shore
dreams I chase are ever yonder.
That sun starts to set in the west, and I stare,
and all that I cared for no longer do I care,
and I stare all the night
'til drew drips from my nose,
as the sun starts to rise,
and my bones are quite cold,
and the peace is quite thick,
and my eyes, still not closed,
and the failure, it goes,
(but the failure...it shows).

As the eyes start to glaze
I finally never have to hear,
"this is just a phase
at 44 years, 4 days and 4 hours my dear".

5/25/2015

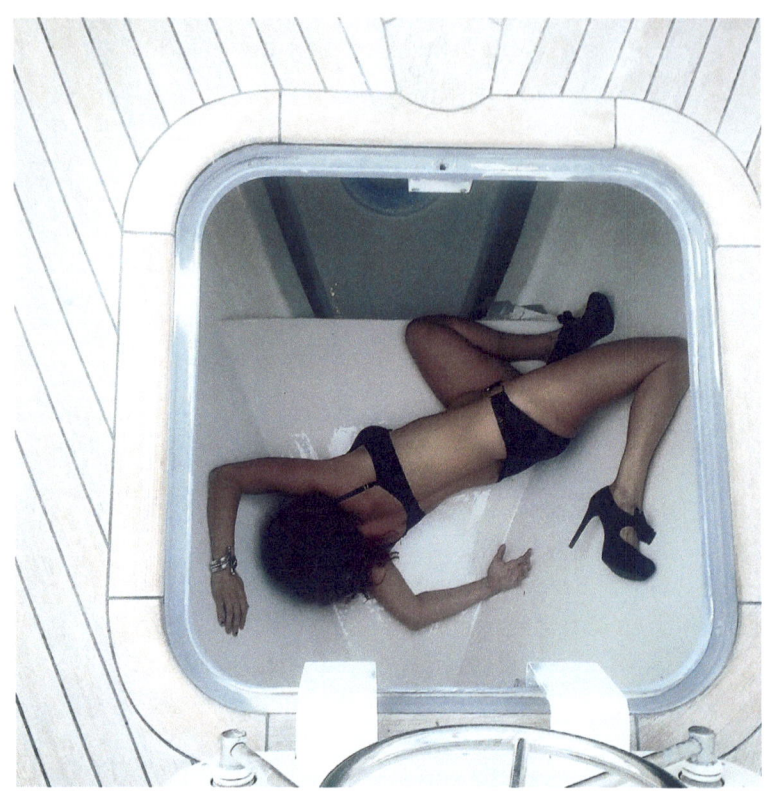

"Down the Hatch"

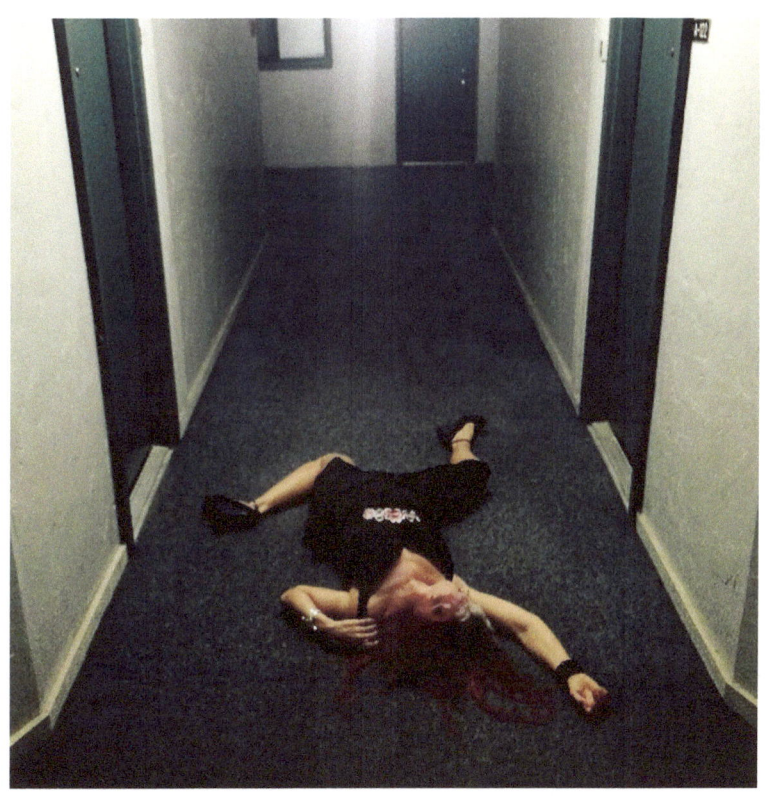

"Let's Go Back to My Room"

Chatter

We fill our time with the the talking T.V.
so we cannot hear the tick of the clock.
and we stay up as late as we possibly can
so we can't hear the crow of the cock.

The booze is abundant,
the days not so much
and our hearts are quite hollow
without human touch.

So, the widows and whores,
and the woman without child
sit 'round their screens
and type well wishes for awhile.

Anonymously enamored by the lives unlike ours
we sit, and we type, and we pass the sad hours.
and the chat is quite charming
loss of time unalarming,
but the vultures are swarming…

and the Death Bed is warming.

12/17/14

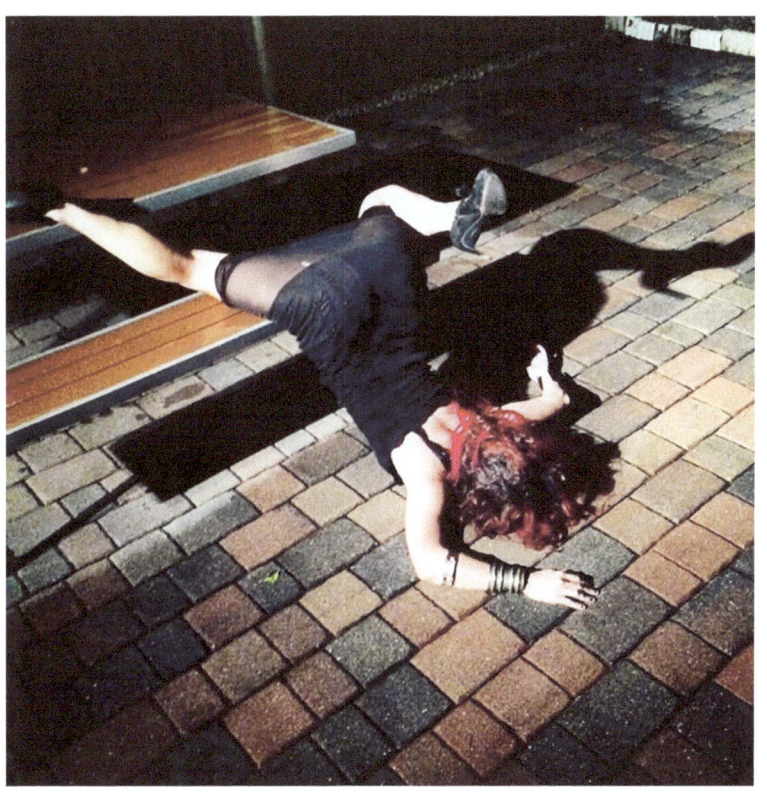

"Table Dance"

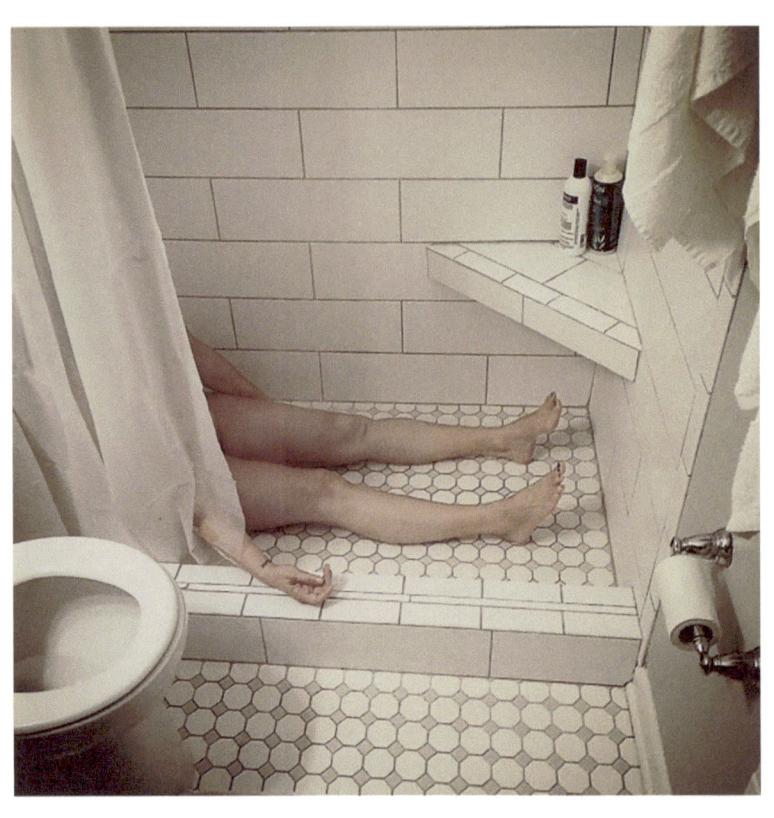

"Calgon Take Me Away"

Grave Tales

"Whan that Aprille",
my mother would recite to me,
"with his shoures soote",
and as those April showers fall
i recall,
some young, some old,
plunged into silence,
left us all.

a bloom crushed,
a mouth hushed,
an eye shut,
a wrist cut,
a hand stilled,
a heart killed.

"The drought of Marche hath
perced to the roote".
Pierced down straight to you,
after rot and mold,
sets in aft the soul
finds flight,
or...
is simply made quiet.

I, too, have lost a love,
stand upon the grave above.
"What if's" still the lure,
and o'er us the falling rain
"bathed every veyne
in switch licour".

6/1/2016

(with special thanks to Chaucer)

No Time

We think we have time,
time to finish the book,
time to finish the painting,
try to re-cast that bad look.

To take back the words,
to reshape that cold stare,
we think we have time,
but the time isn't there.

We think we have time
to squander time that "we got"
but remember silly boy, silly girl,

we.
do.
not.

1/20/2016 - 2/4/2016

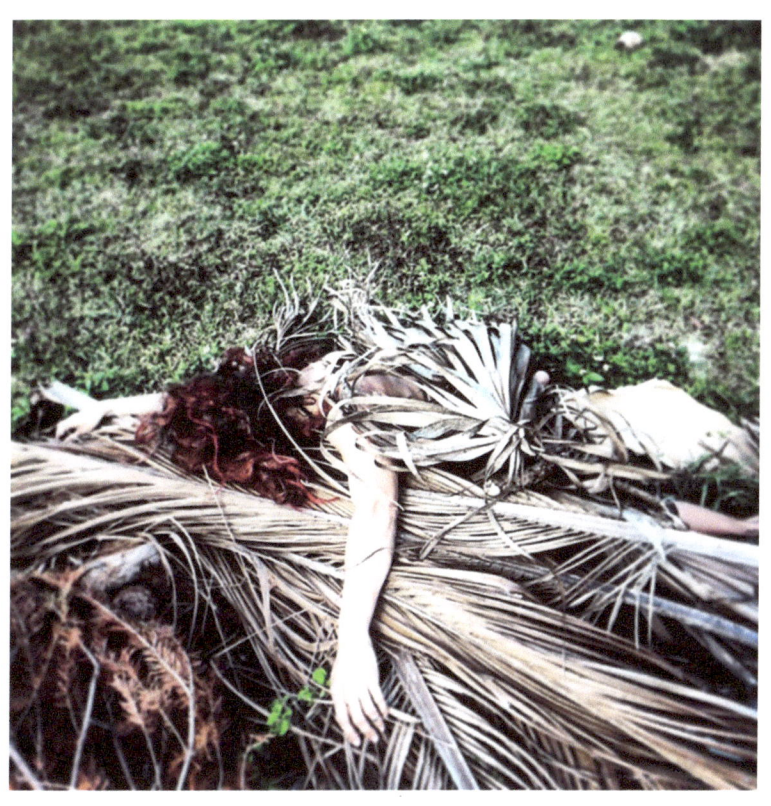

"Landscaping 101"

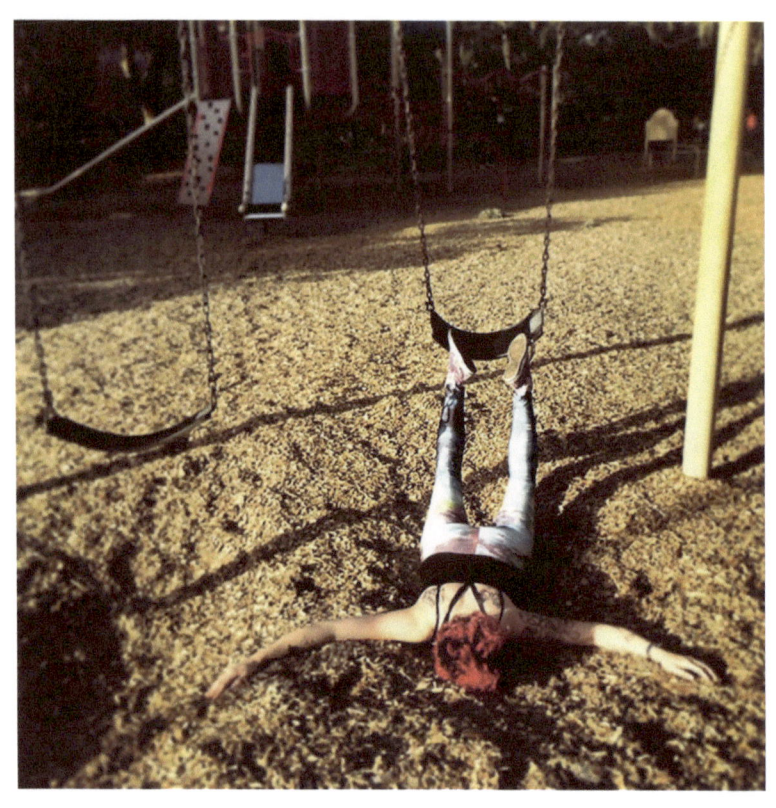

"Play Nice"

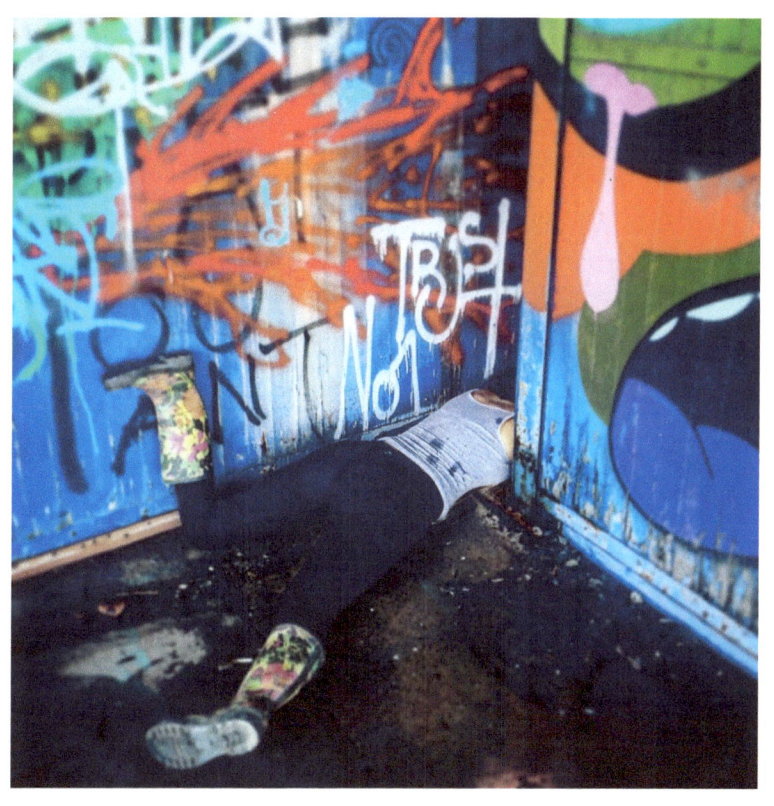

"Urban Exploration"

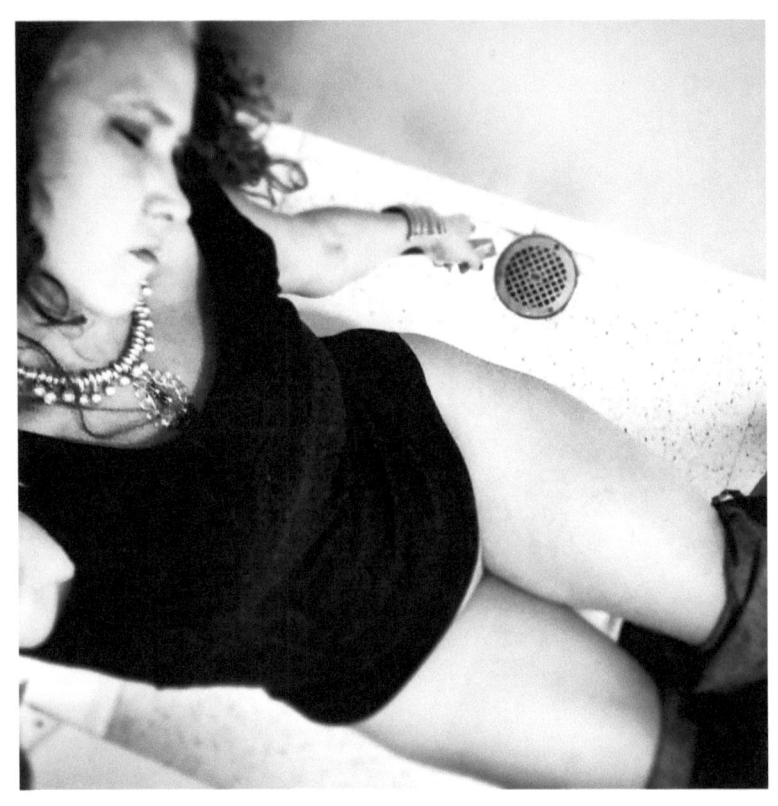

"Medicine"

Takes 2

It takes 2 now to tuck me in,
2 pills to create that perfect Zen.
2 tears to roll down my cheeks,
to remind me of the time since you left-
 2 weeks.

2 months, 2 years,
too soon to forget
the time we spent
since the time we met.

Too long to be sad,
too sad to move on,
too tired of regret
from the things i did wrong.

I'll take 2 more
or as much as i can get
to sleep all night,
all my life,

and forget.

March 2014

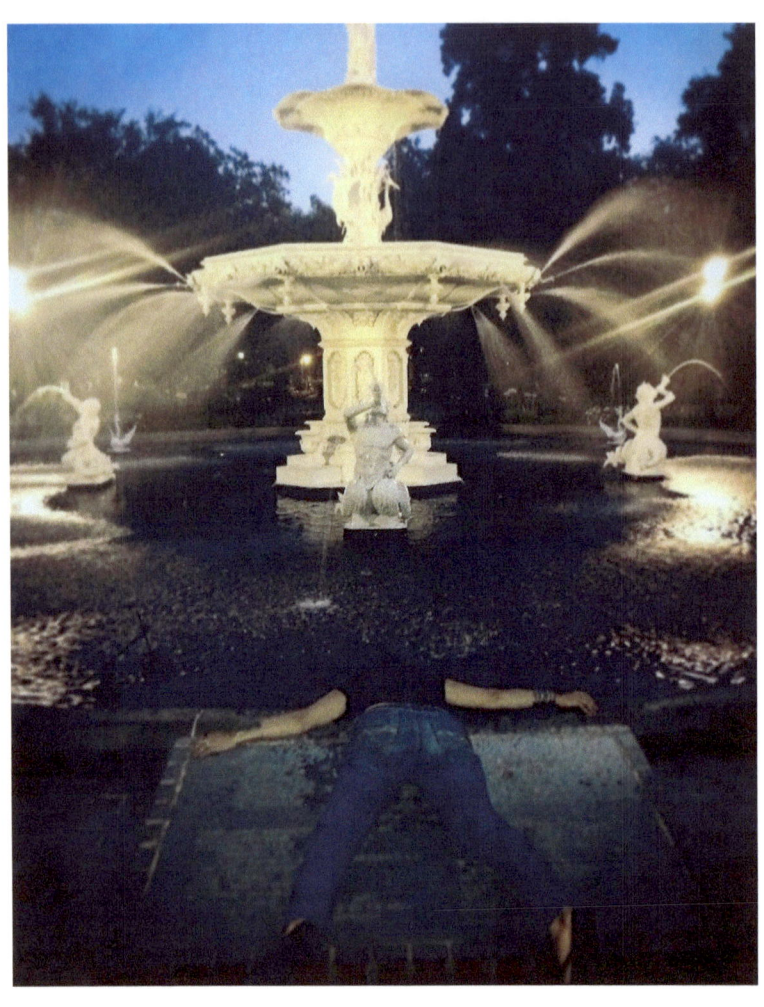

"Tourist Trap"

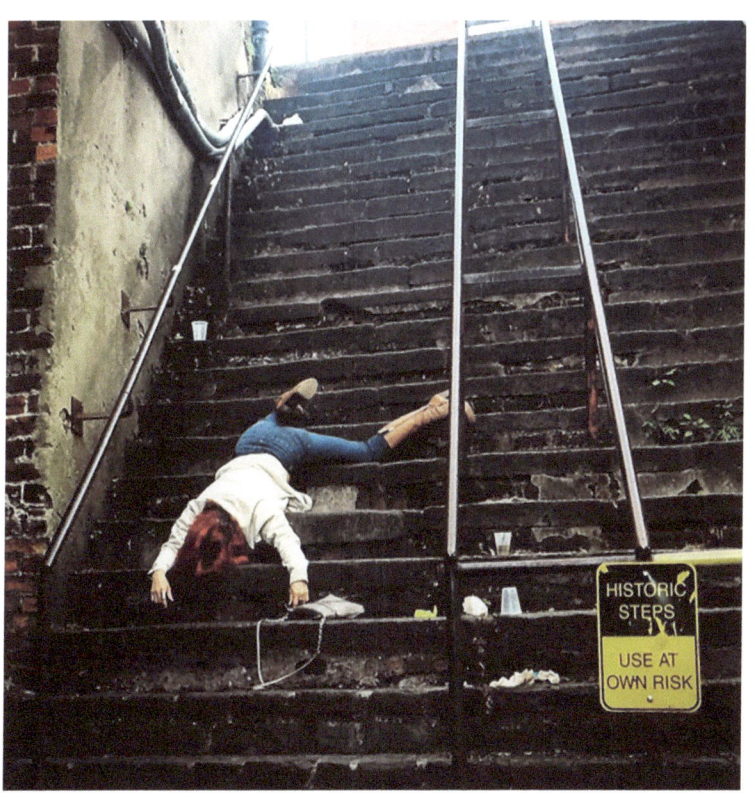

"Use at Own Risk"

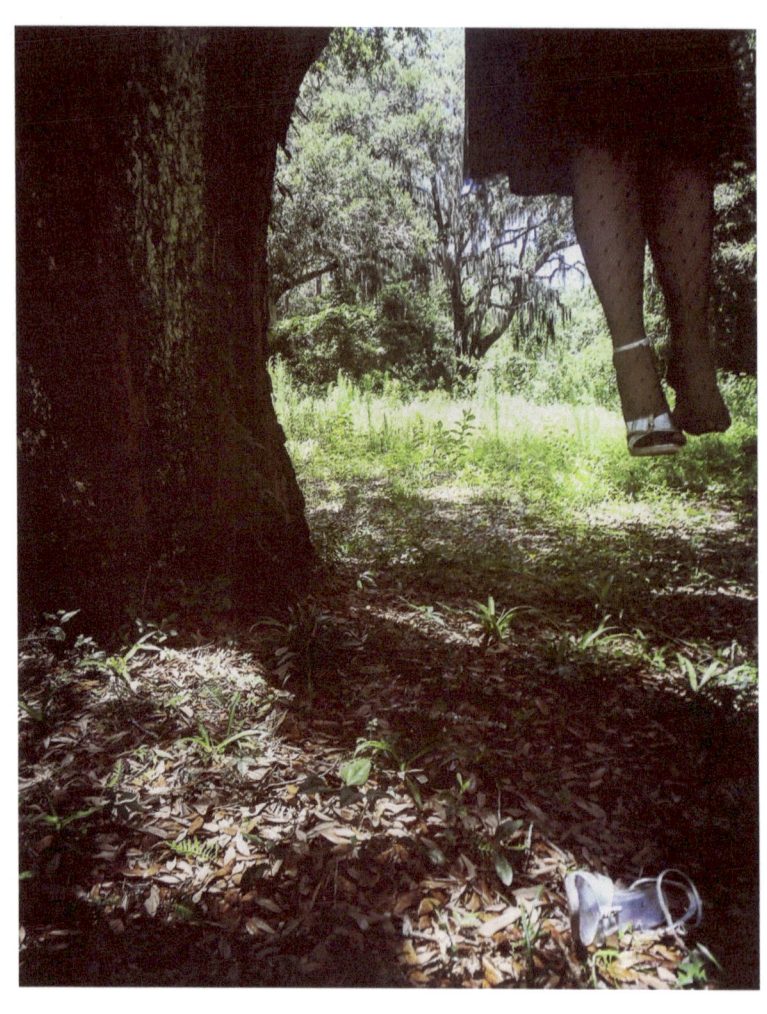

"All I Wanted to do was Hang With You"

Putrefaction

The place I laid right next to you
is cold and covered with dust,
and though your lips never needed mine
for me it was always a must.

It didn't matter that I drew the curtains
you did not question when I stopped the clocks,
and taking down the mirrors and photos
didn't illicit a saddened response.

I am old enough to know the poisons I like
and pluck each one for a certain pain,
but this putrefaction from loves atrophy,
this waxing of your punishment must wane,

and the disintegration of these 20 years
has left us, like cardboard, quite plain.

But the ropes from the trees are now coiled in their boxes,
the cutting devices placed under stones,
and the only weapon left that inflicts any pain
is the silence between us that has grown...

and the silence that has left me alone.

6/25/2015

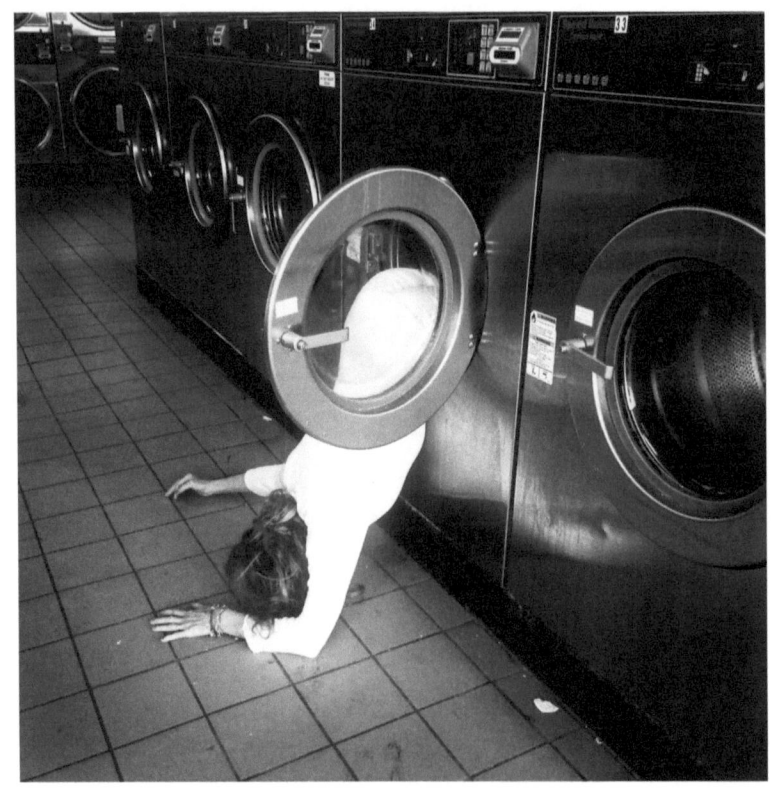

"My Head is Still Spinning Ever Since I Met You"
(Wash Cycle)

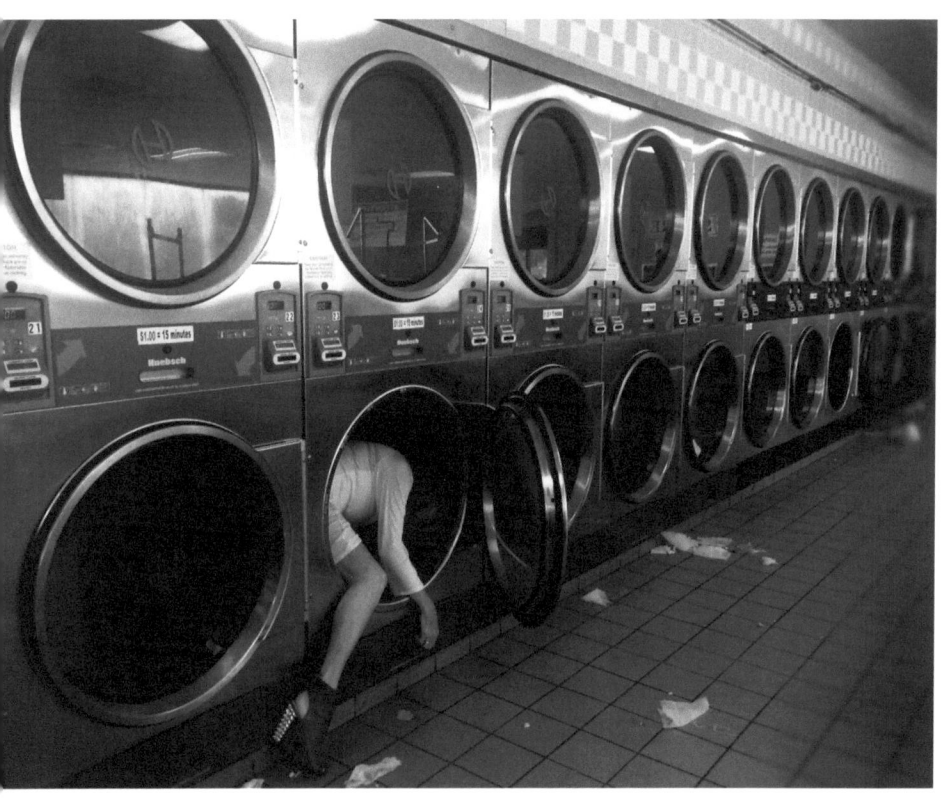

"I'm Done"
(Drying Cycle)

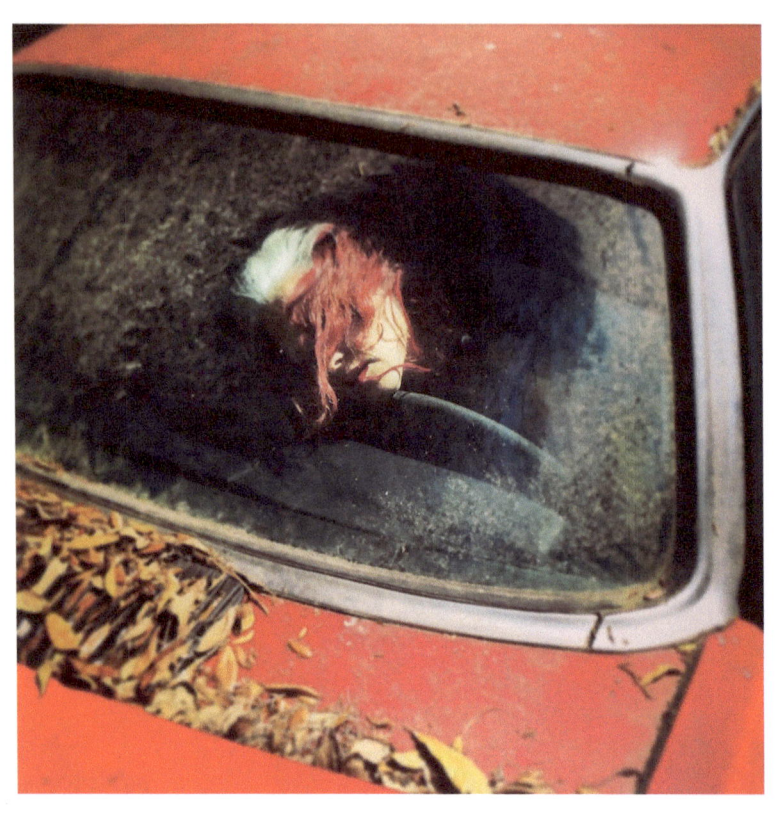

"Used Cars"

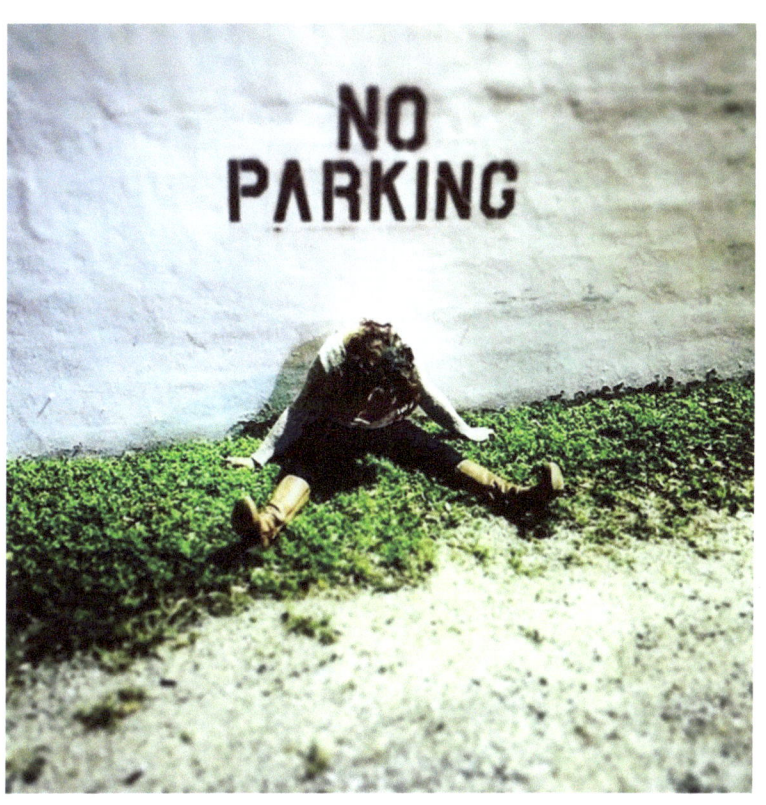

"No Parking"

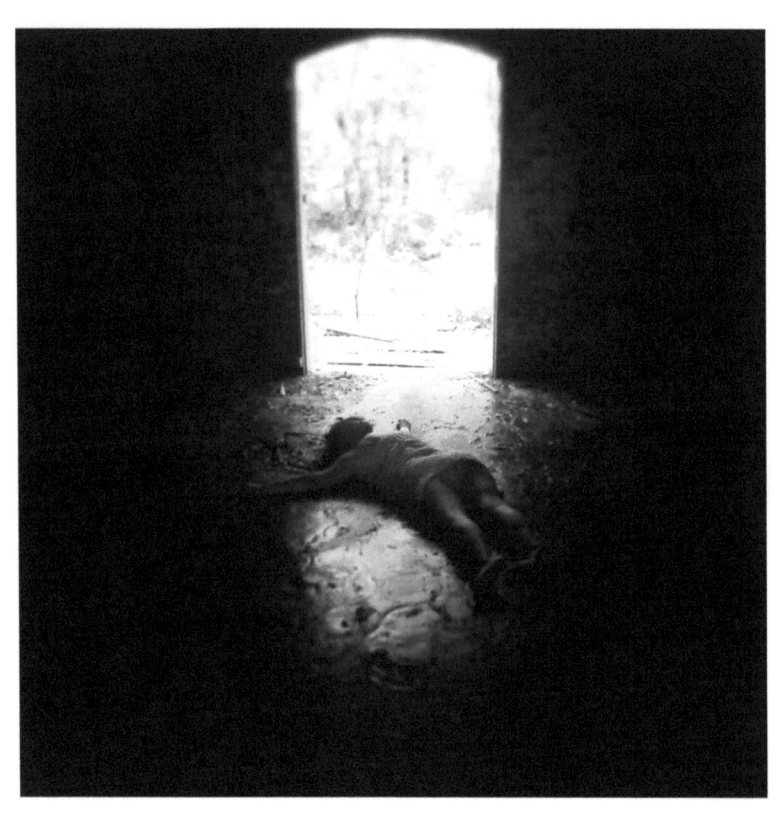

"I Saw the Light...(and almost reached it)"

Cemetery Gates

a monumental reminder
to walk amongst concrete honors

great tribute to dead Gods,
dead mothers and dead fathers.

and stone, immortal love,
for dead children and
dead fodder.

i walk amongst the history
reminded of Egyptians
and standing water,

of sinking earth and
bloated babes,

little Oliver
and Baby Kate.

some seek solace with
the spirits long rushed,

but all i know of this place...
hope is hushed.

5/8/2016-6/1/2016

The River

as i open my mouth
i become the muddy river
cold and caressing,
to the hopeless a blessing

a long, expectant death,
the loving suffocation,
the finite struggle,
panicked eyes anticpate
the strangle

but the river
she is mother
"take me in..
there is no other
that will hold you like I,
to my bosom as you die".

slipping beneath her surface
looking up above her waters
washing over the sad face,
the surrendering countenance

a lingering embrace

the heavens watched me
sink below the surface for awhile
the last vision,
through swirling waters?

a smile.

8/1/09 -6/20/2016

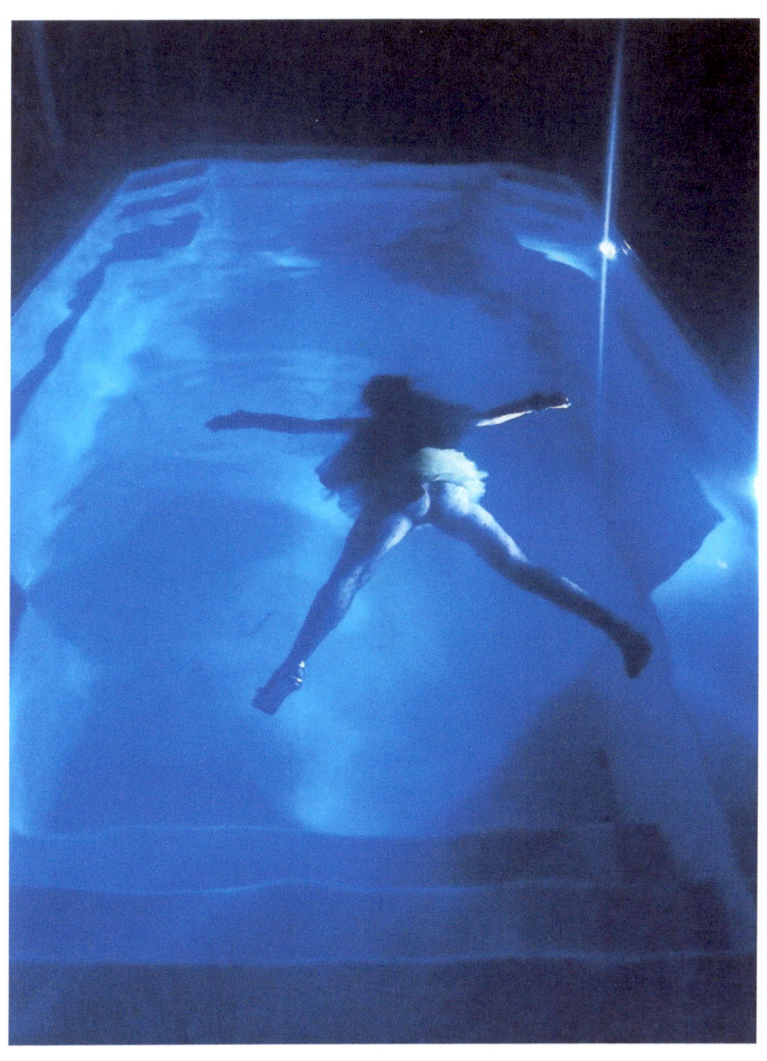

"Come on in the Water is Fine"

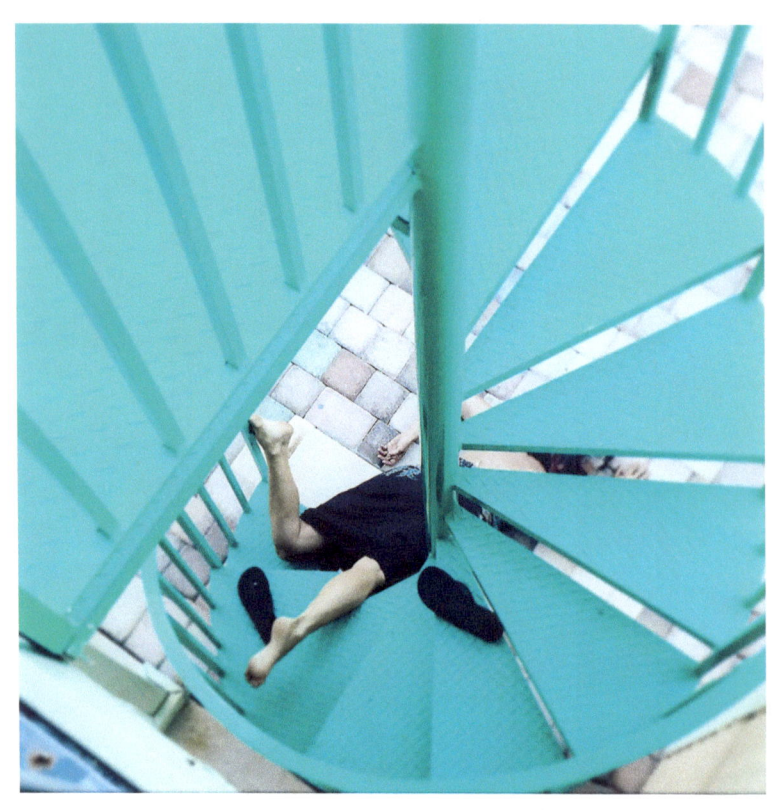

"Watch Your Step"

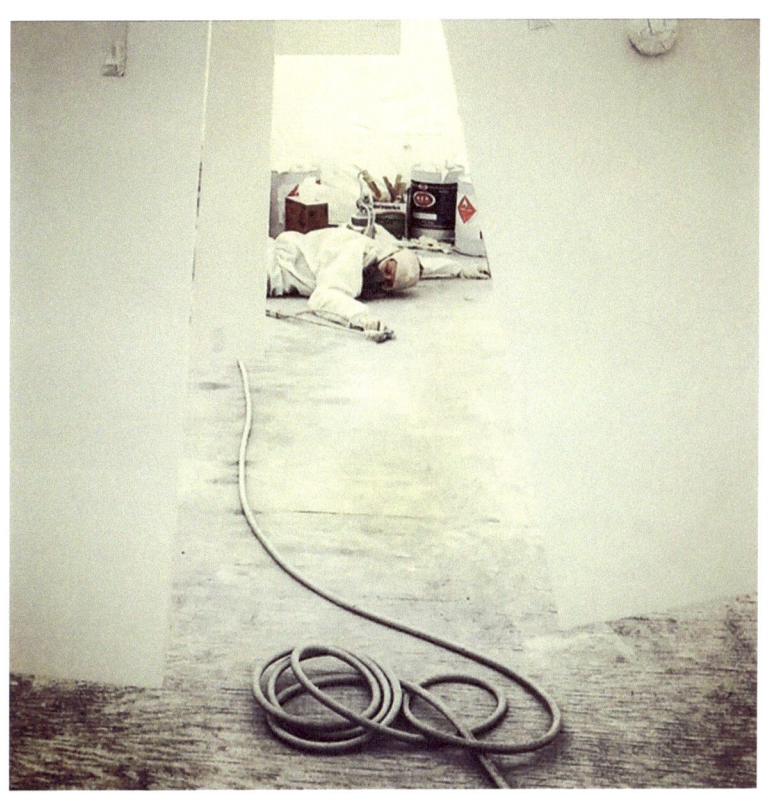

"CAUTION: Paint Fumes"

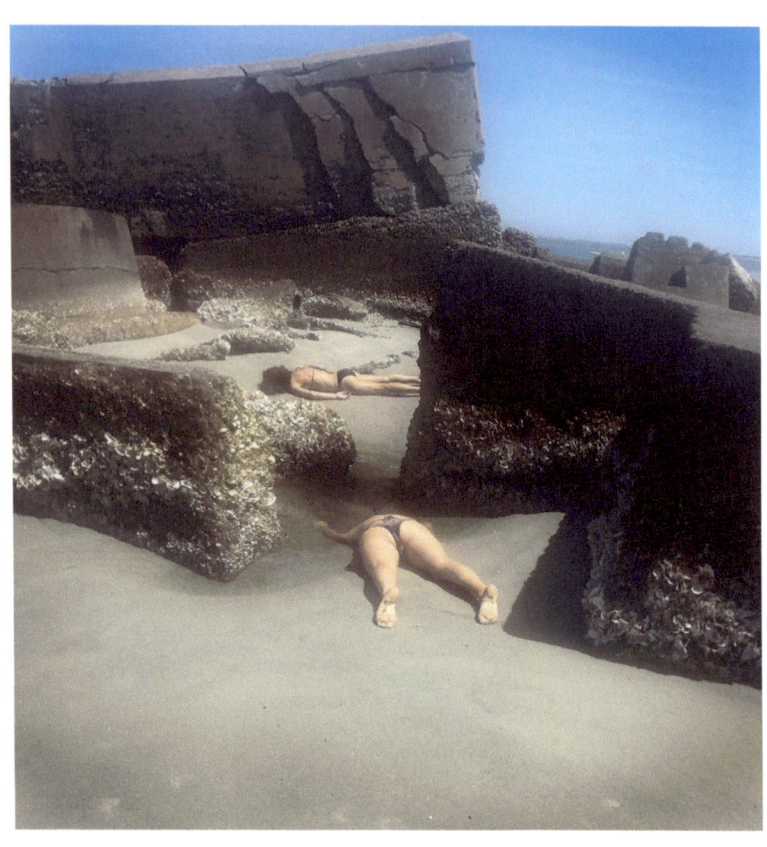

"All Washed Up"

Lost Kisses

I'm throwing kisses irrevocably into a chasm,
and I cannot see the bottom where they fall,

where they lie broken on the rocks
or torn on the thorns,
abandoned.

My eyes chase each one that I toss out
into the wind,
and the sky is growing dark.

There is a vast lake in the distance,
and it grows tar black and has no end,
but oozes up into the blue, bruised night
only punctuated with diamonds, sapphires
and amethysts...

They mark the shore that melts into the sky.

Some of my kisses may have landed there
and lie in sand that will wash over them
never to have known lips,
but only the open mouth of the sea.

They drown in her.

12/27/2014

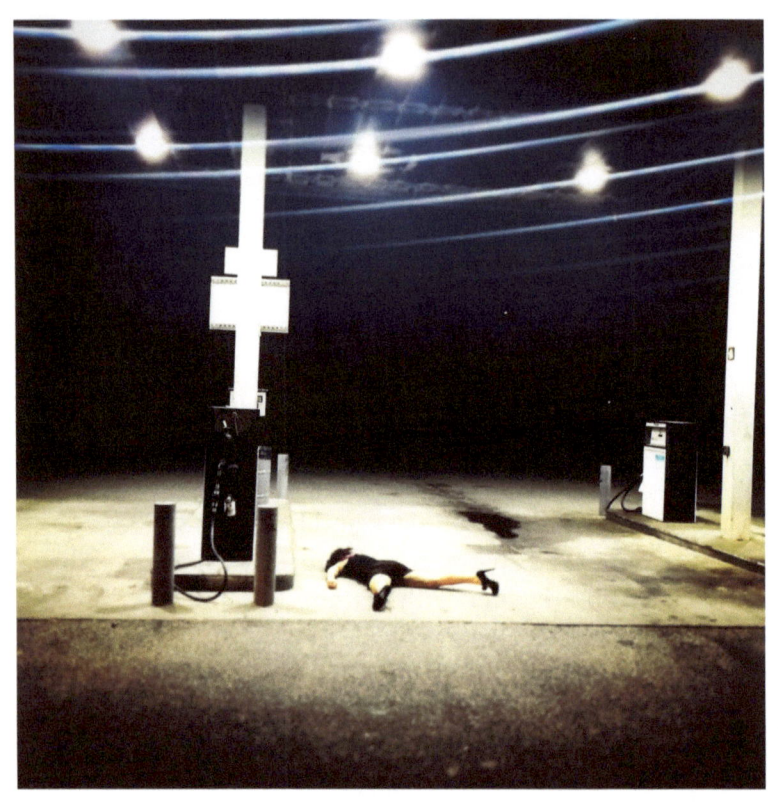

"A Convenient Stop"

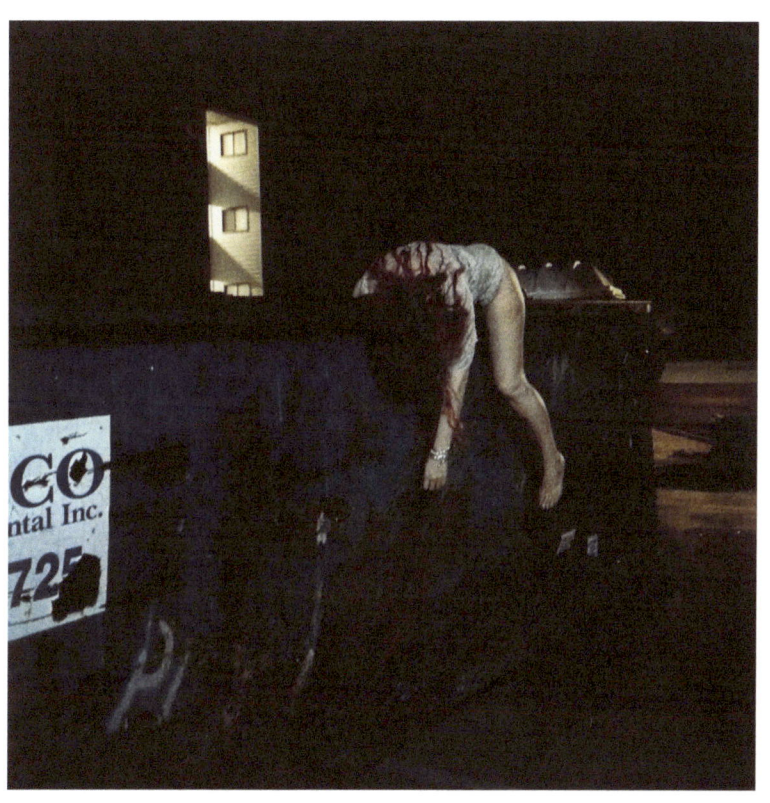

"DumpstHER"

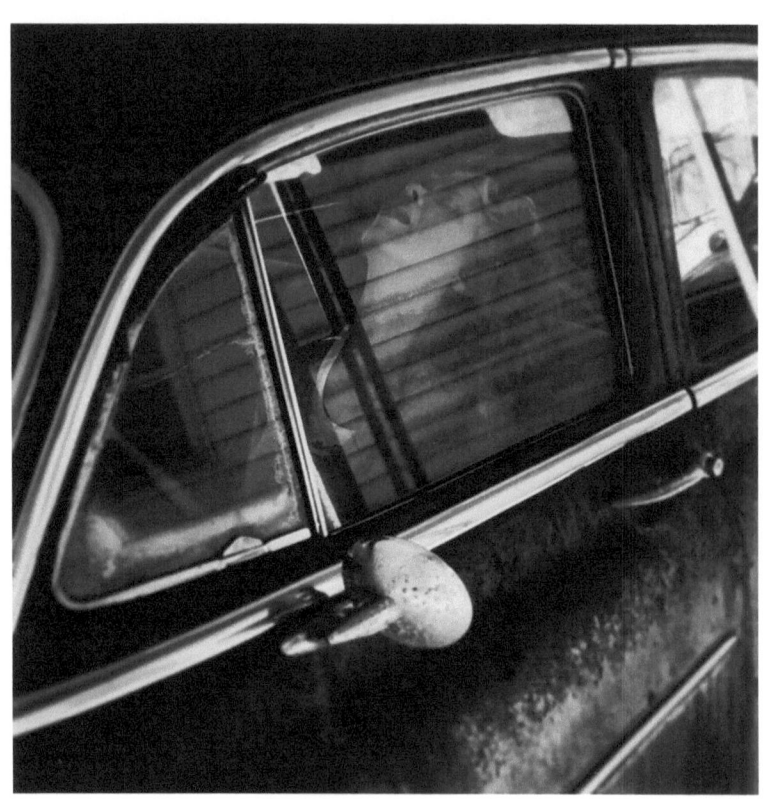

"I Love this Car to Death"

Osmosis

a repugnant osmosis...

the daughter is stepping into mommy's well-worn shoes,
her loving shoes,
her dirty shoes.
and the babe has slipped into the dirty grave.

Mama's got the scrapbook,
and I've the tiny toys saved.

the muddy, bitter pill,
the dirty memory pain,
just a tad of shame
(a little shame)
that everyone is sane.

enough,
to bluff
with sideways smiles
and mascaraed eyes
"reapply, reapply"!

and how you can wake
while I die,
how I'm the honest,
and you are the lie.

the shoes now just a shuffle...
I, just a scuffle with sweaty sheets,
a heart that beats.

and the babe?

waiting in a grave for a dying woman
she must meet.

12/29/2014

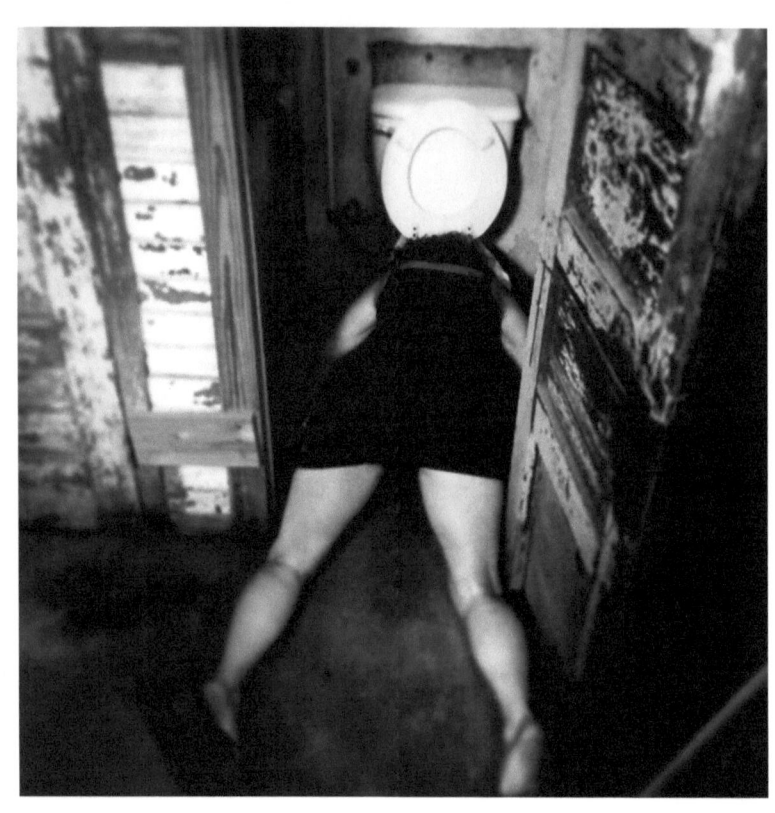

"I Feel Shitty"

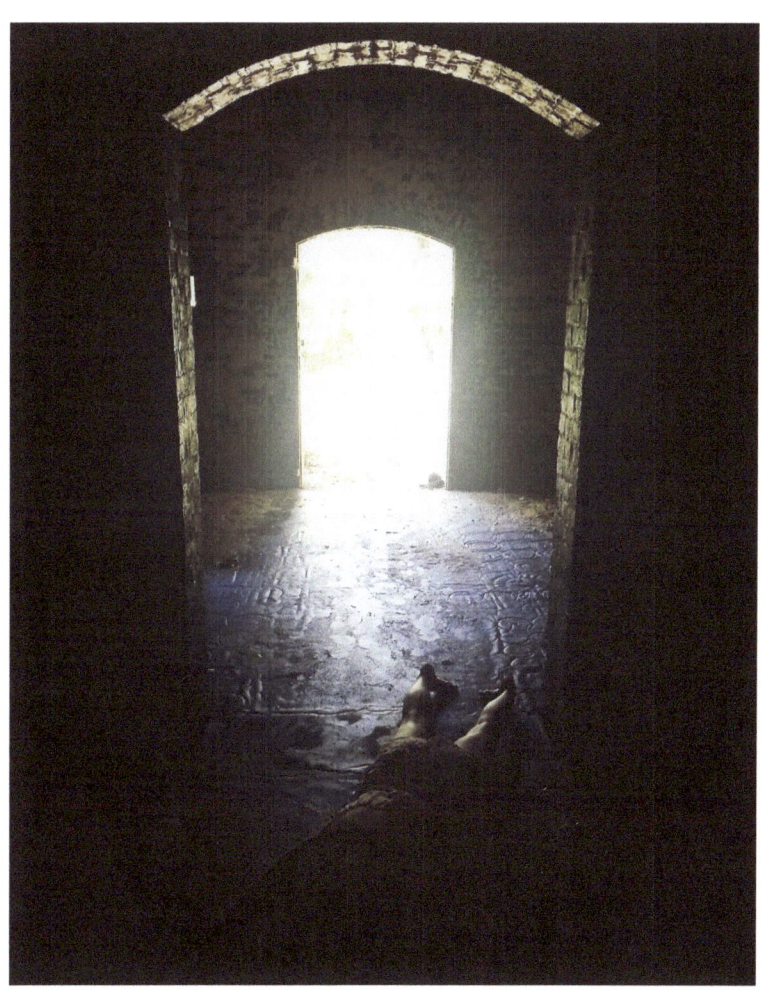

"No Place for Me in Heaven"

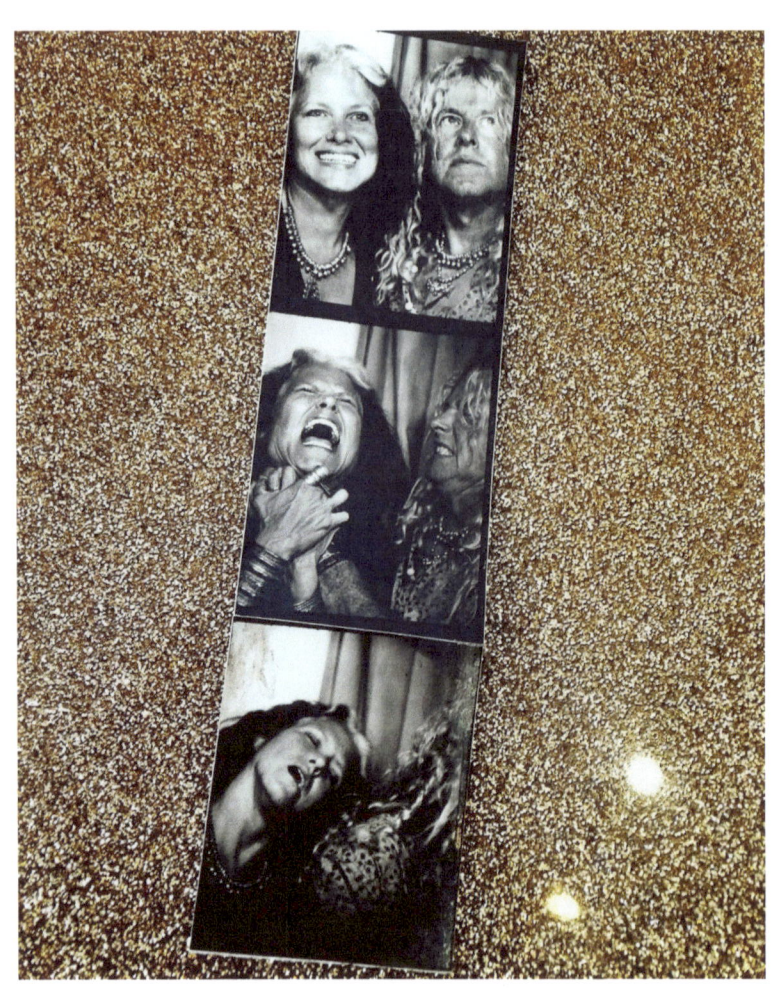

"He Loves Me, He Loves Me Not"

That stone cold vault
is where we put our love.

Buried along with that little death,
two destructions.
two deaths.
two horrors.
two regrets

one grave.

2007-2016

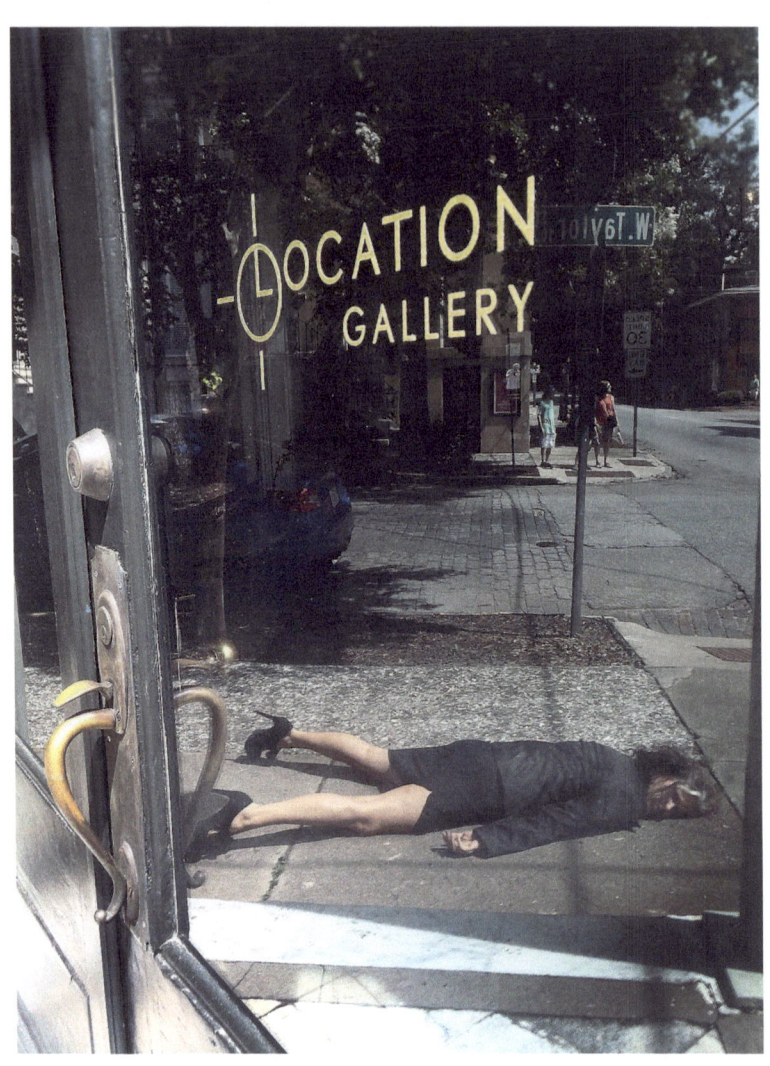

"Art Attack"

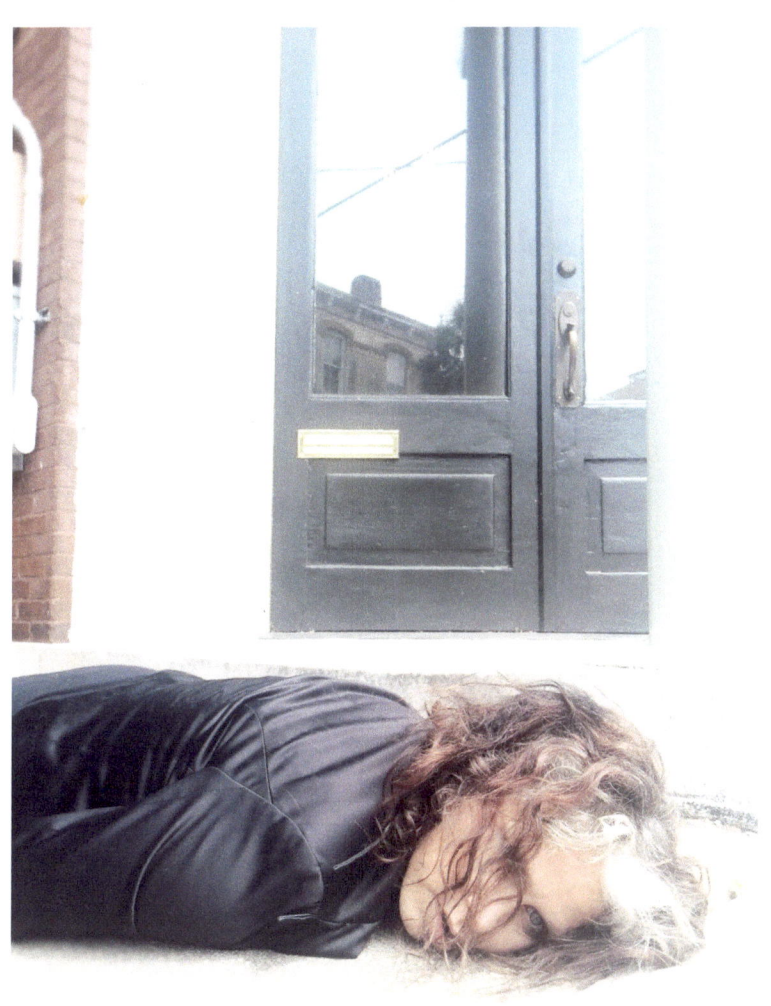

"The End"

This book is not only a personal vision but also a collaboration,
and I'm just dying to thank you all.
It would not have been possible without
the assistance of the following:

Michael Findeis: Primary, photographic assistant,
as well as "actor" in
"She Loves Me, She Loves Me Not"

Martha Chapman: Photographer for
"Hey Good Lookin, What's Cookin?"

Peter Roberts: Photographer & Collaborator for
"Art Attack" and "The End"

"Stunt" Doubles:

Sarah Cuda: "Play Nice"

Monica McMasters:
"My Head is Still Spinning Ever Since I Met You"
and "I'm Done"
(The Washer & Dryer Series)

Additional Actress:

Tammy Lambert: "All Washed Up"

Special thanks to **Travis Sawyer** of **Creative Approach Savannah** for assistance in the layout...
and for not KILLING me with all my questions,
Peter Roberts & **Location Gallery** for hosting my pop-up show
"The Dead Girl Diaries",
the photobooth at **El-Rocko Lounge,**
the toilet at **Southern Pine Company of Georgia**,
& **Amy Gaster** for the use of her pool on one chilly
New Year's Eve Night.

Your kindness and support just KILL me.

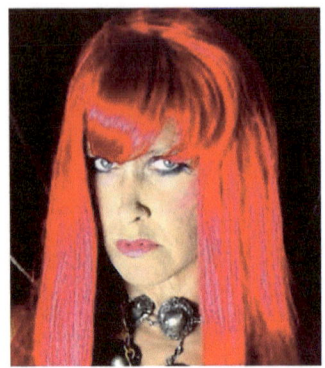

Shelley S. Smith is an artist, photographer, and welder living in Savannah, GA. She was born and raised in Greewood, MS in the Delta. She studied philosophy and sociology at Rhodes College in Memphis, TN and photography at the Savannah College of Art and Design in Savannah, GA.

This is her second publication. Her first was, "The Children's Garden", a childrens book and journal of her travels to Haiti illustrated by the children she worked with. 100% of the proceeds of that book go to the orphanage she supports. Both books are available on Amazon.

She hopes to live long enough to return to Haiti, continue her art projects and create more books.

www.ingramcontent.com/pod-product-compliance
Lightning Source LLC
Chambersburg PA
CBHW040902180526
45159CB00001B/492